This Book Belongs to

..

I am fearlessly made

an Adult Coloring Book

Copyright 2019 by Teresa Scott Dobson

ISBN– 9781798875506

Cover and Interior Art by Teresa Scott Dobson

All rights reserved.

Printed in the United States of America.

I am fearlessly made

Before You Get Started!

1. Put away all of the worldly distractions around you -- TV, phone, computer, etc.
2. Take out some color pencils, markers or crayons.
3. Pick a page and go with it. There's no particular order to follow.
4. When you finish a design, personalize it by signing your name anywhere on the page.
5. Stop when you need a break, then pick it up again later.
6. When finished, if you desire, share your creations with others!

This book is dedicated to my sister Tammy Linzy.

She challenges us to:

Be brave. Be strong. Be fearless. We are never alone.

Joshua 1:9

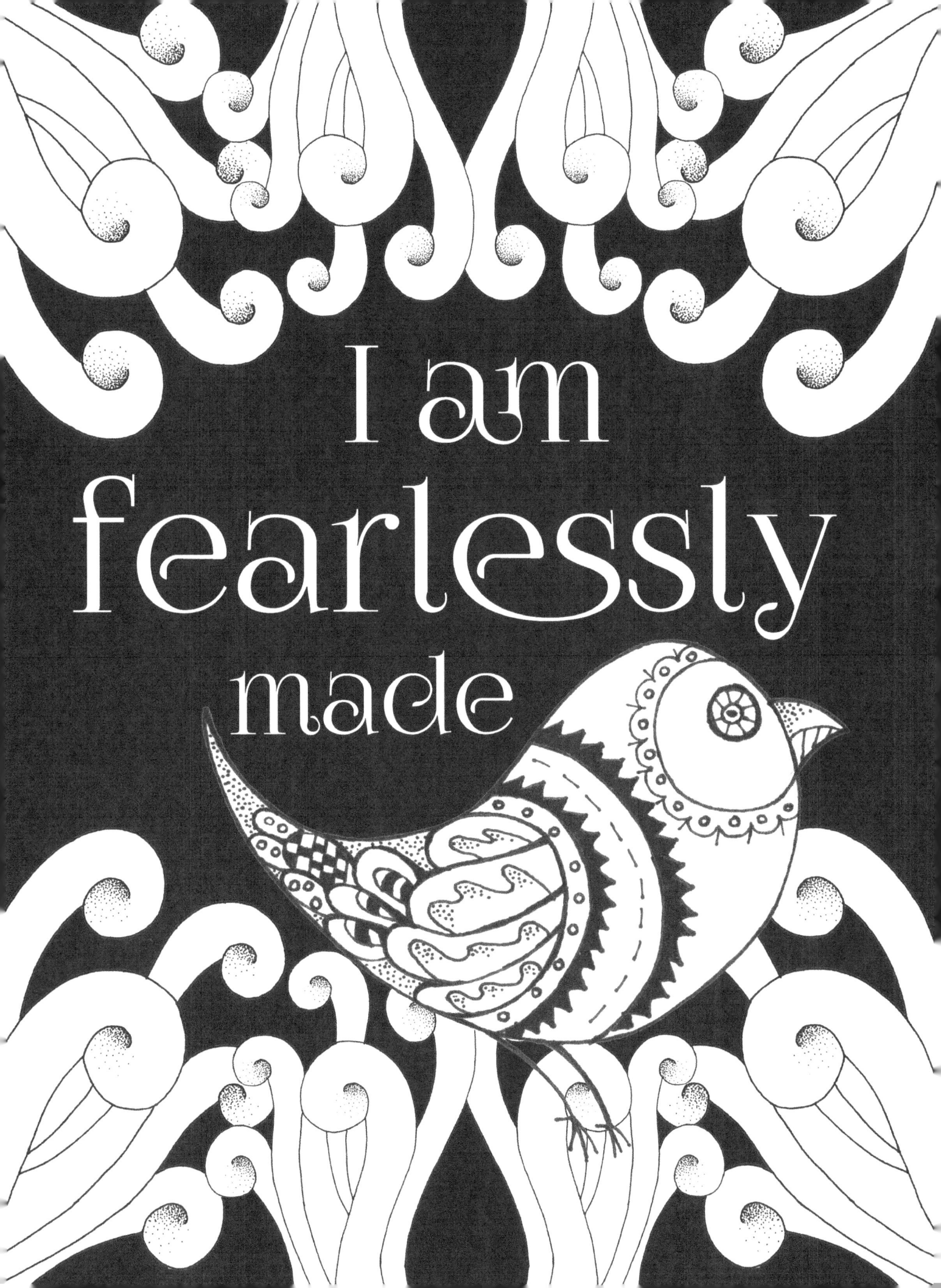

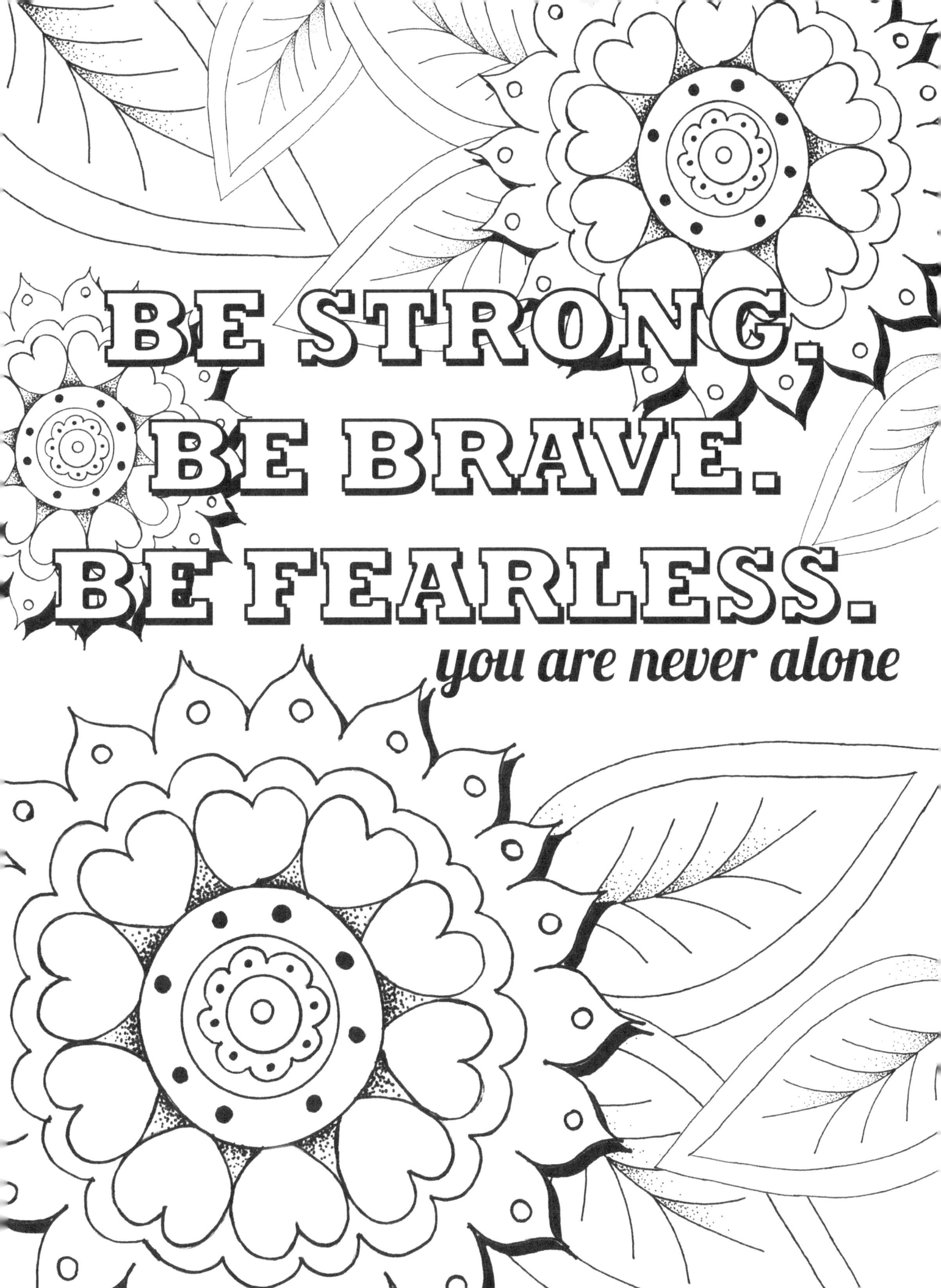

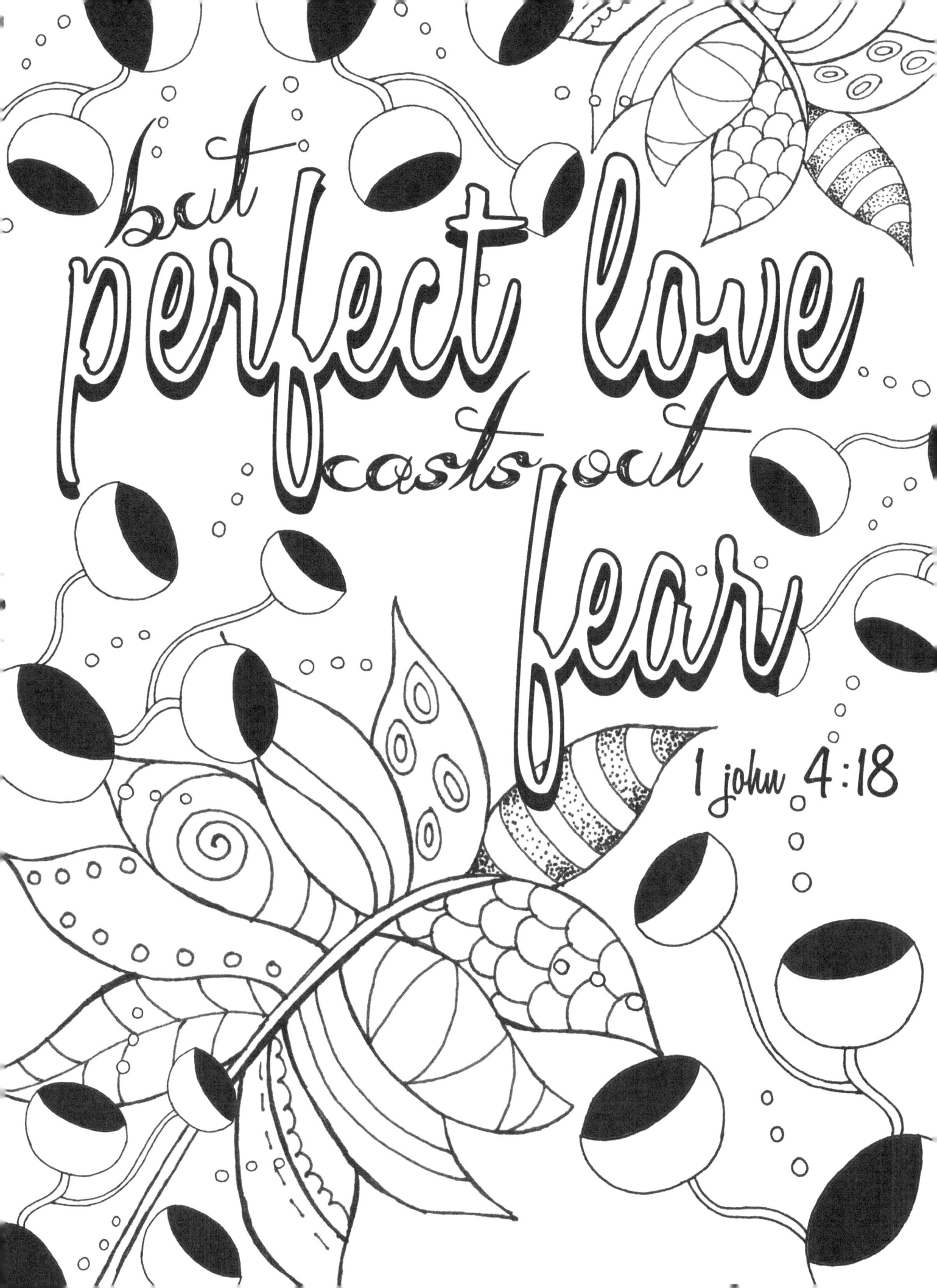

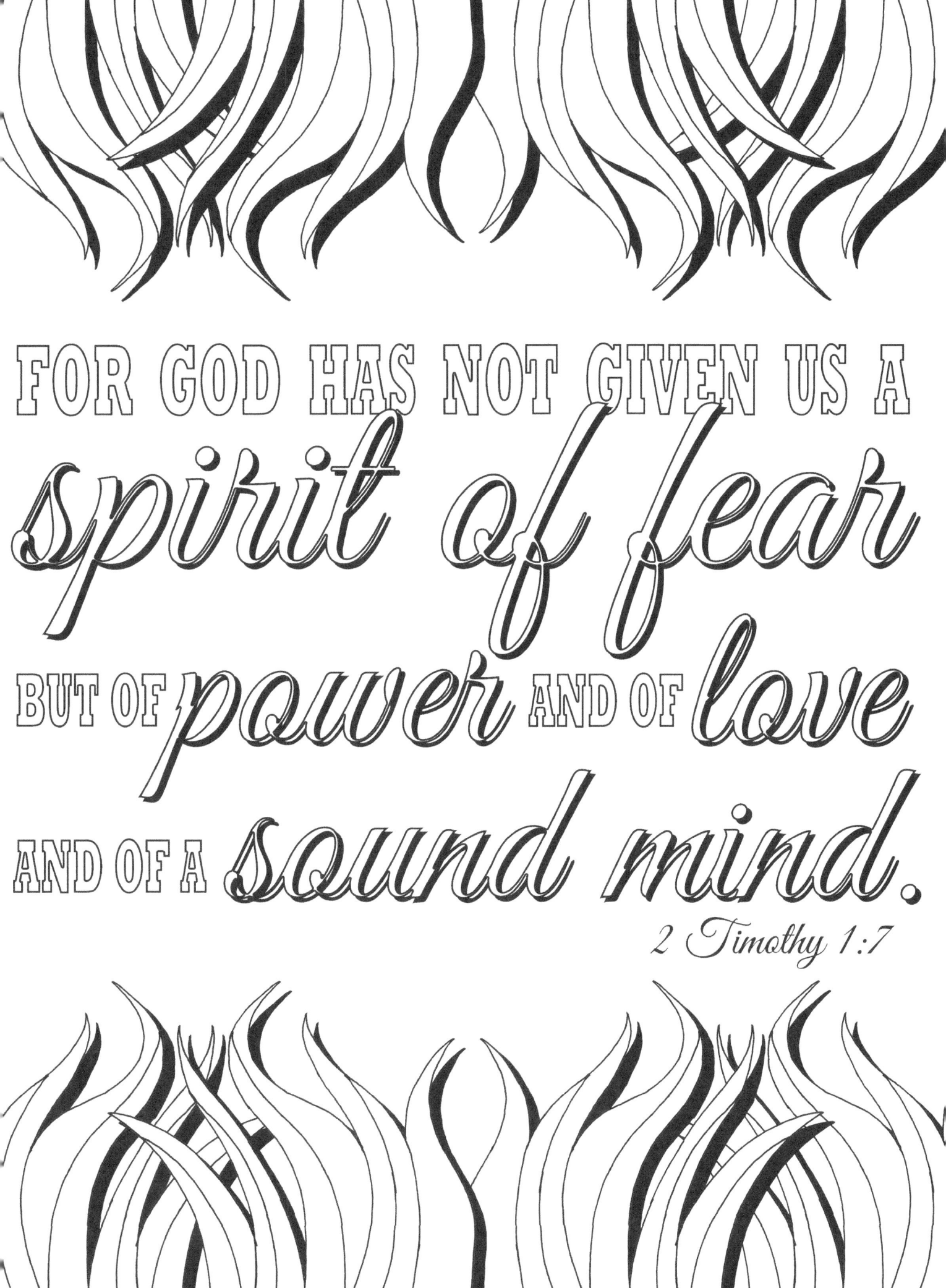

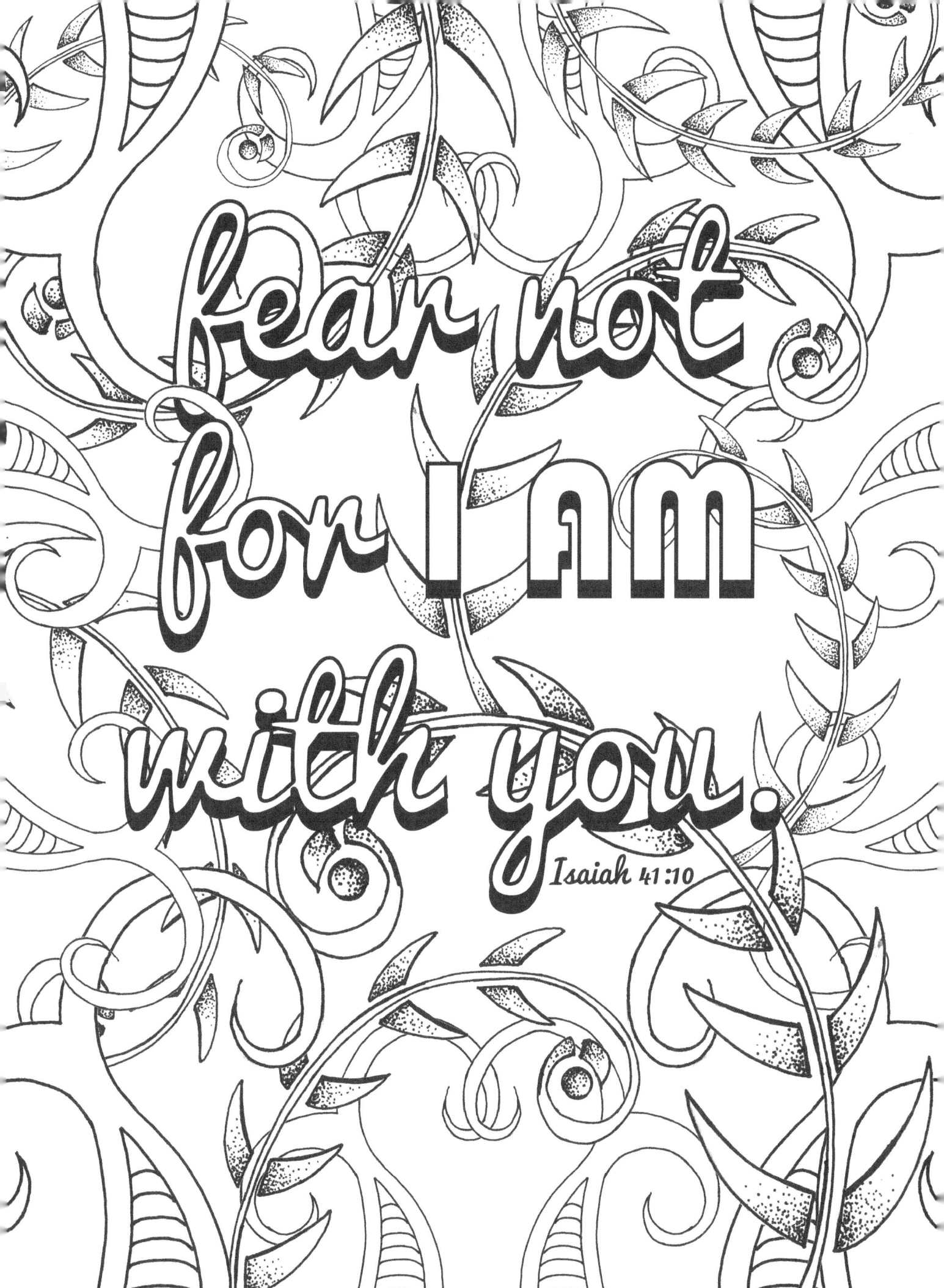

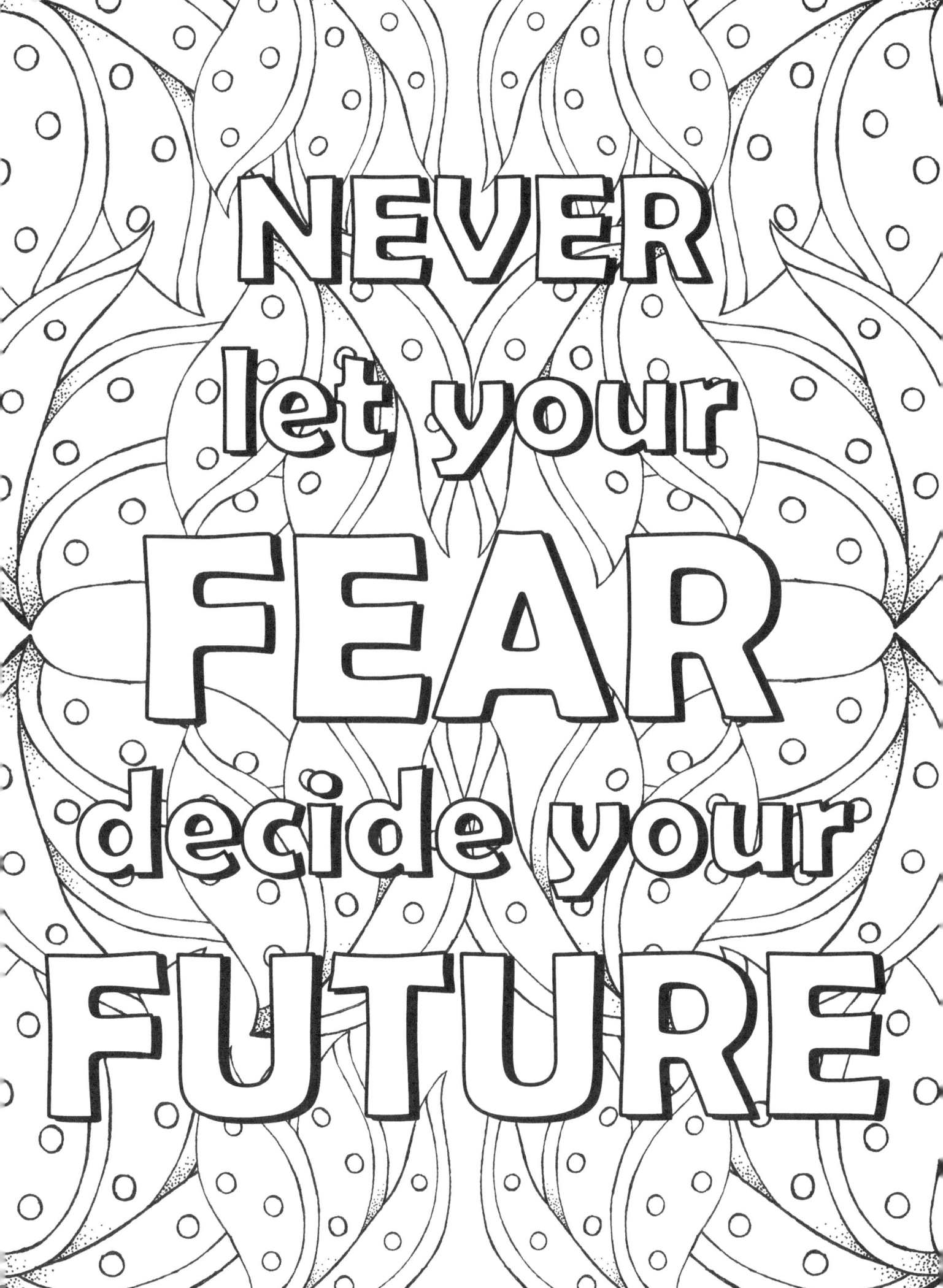

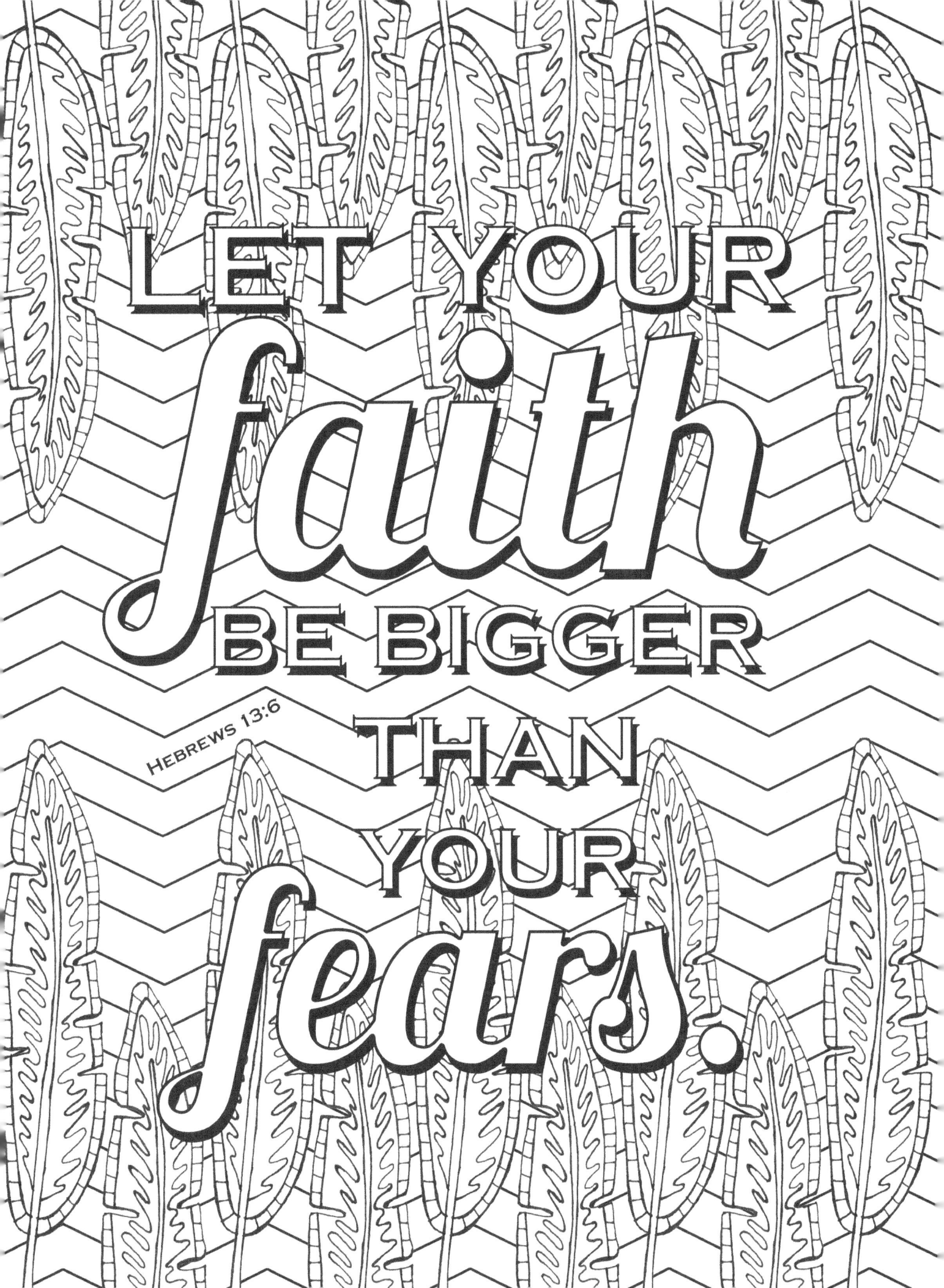

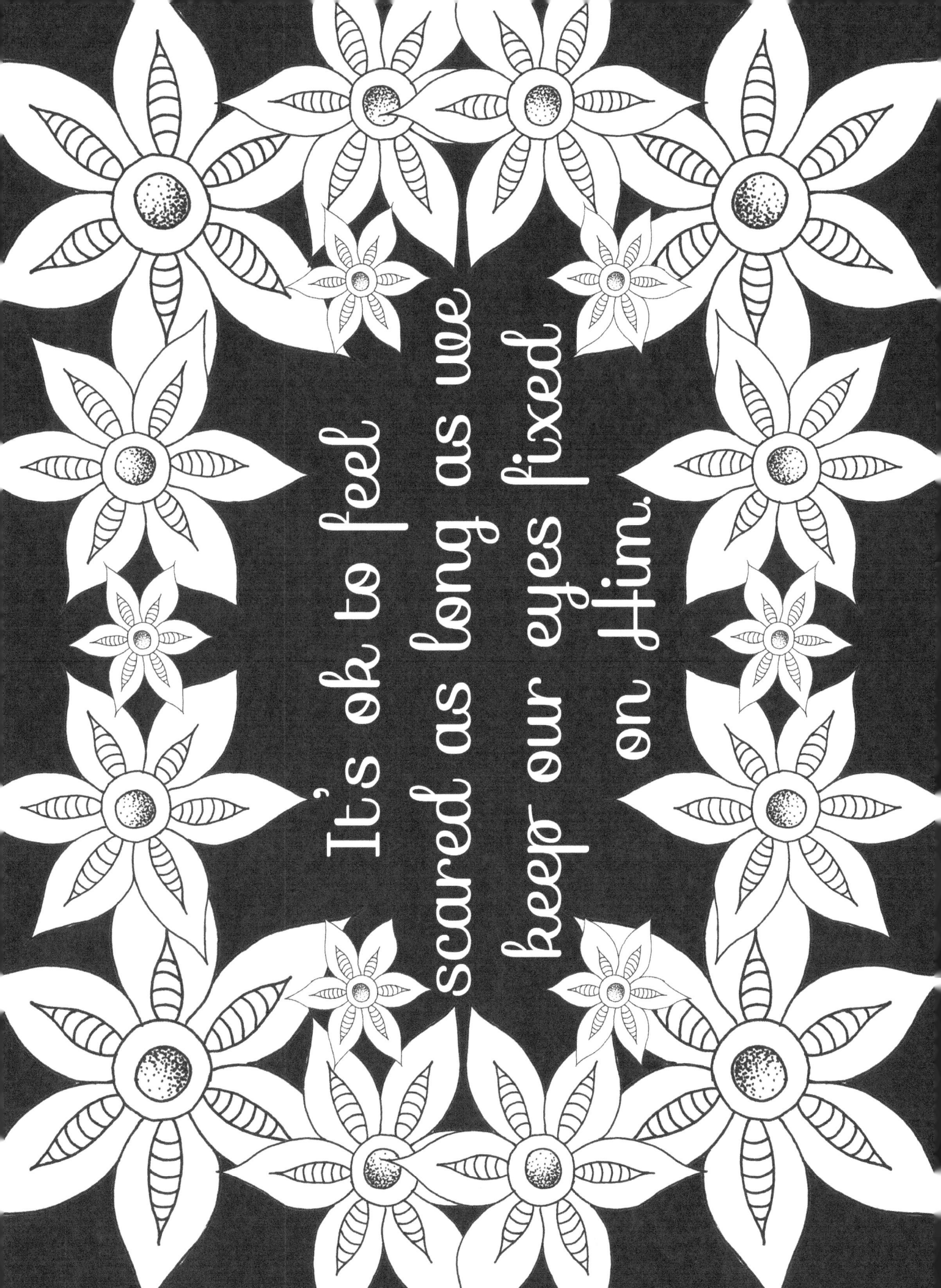

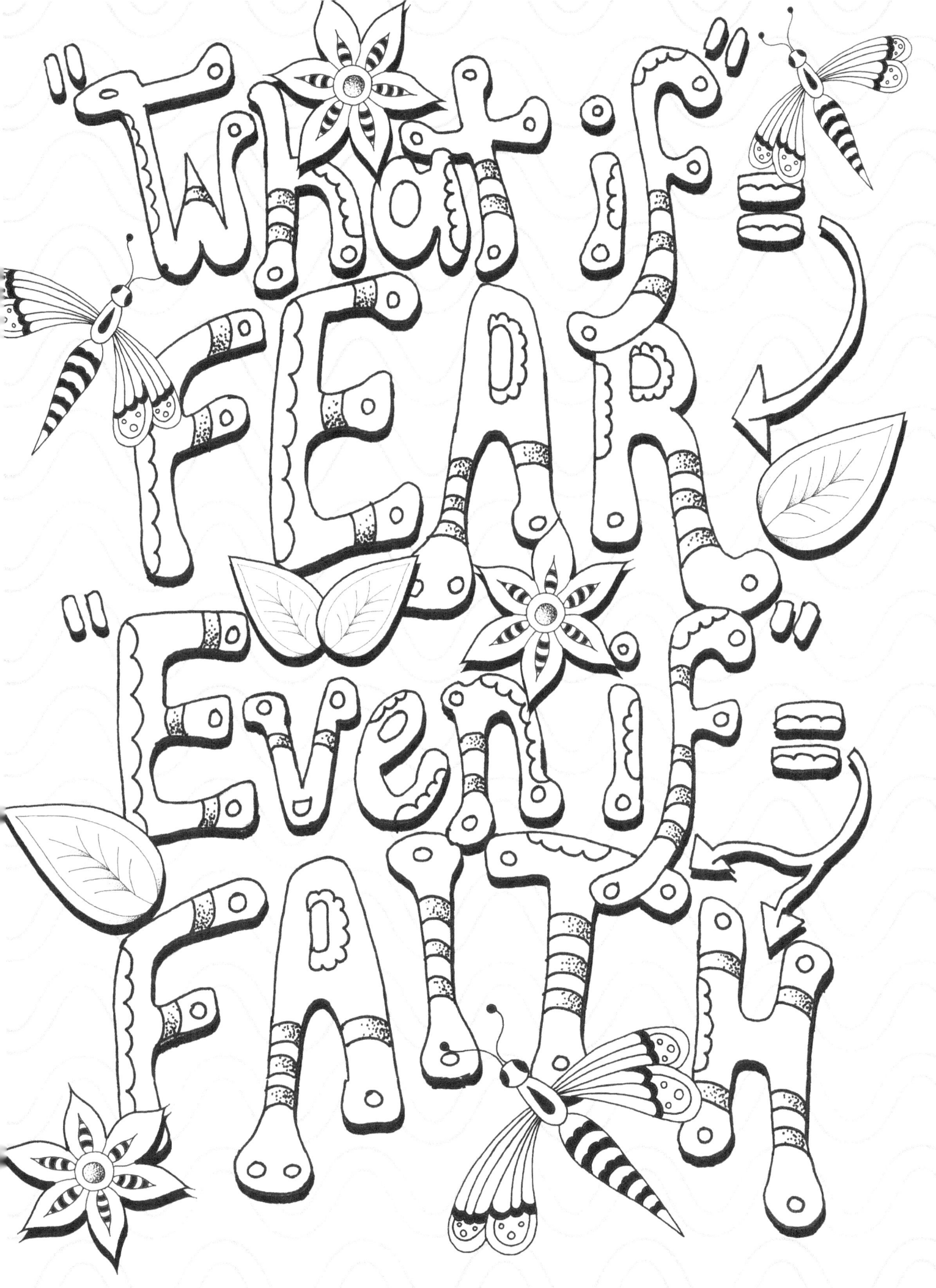

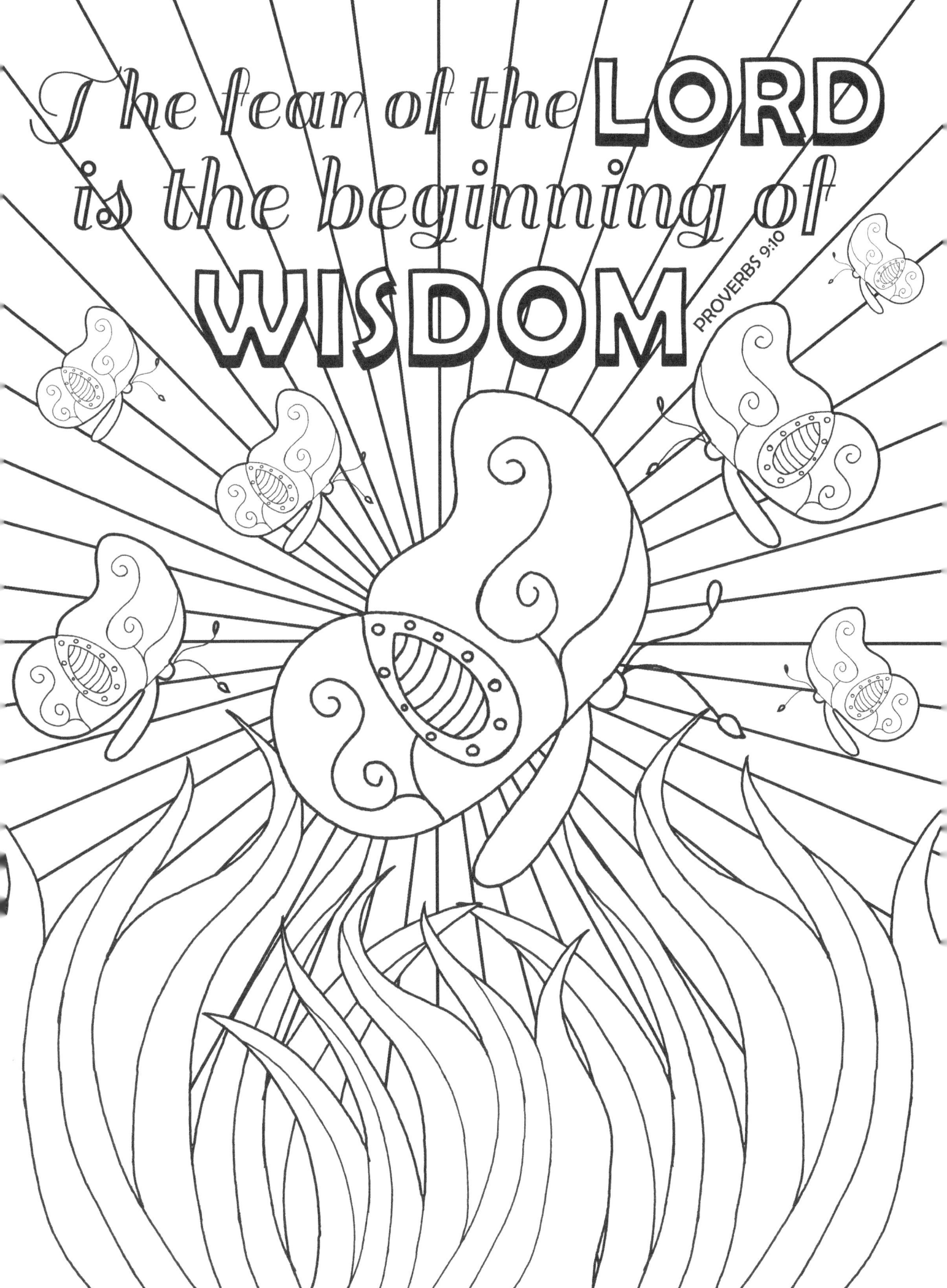

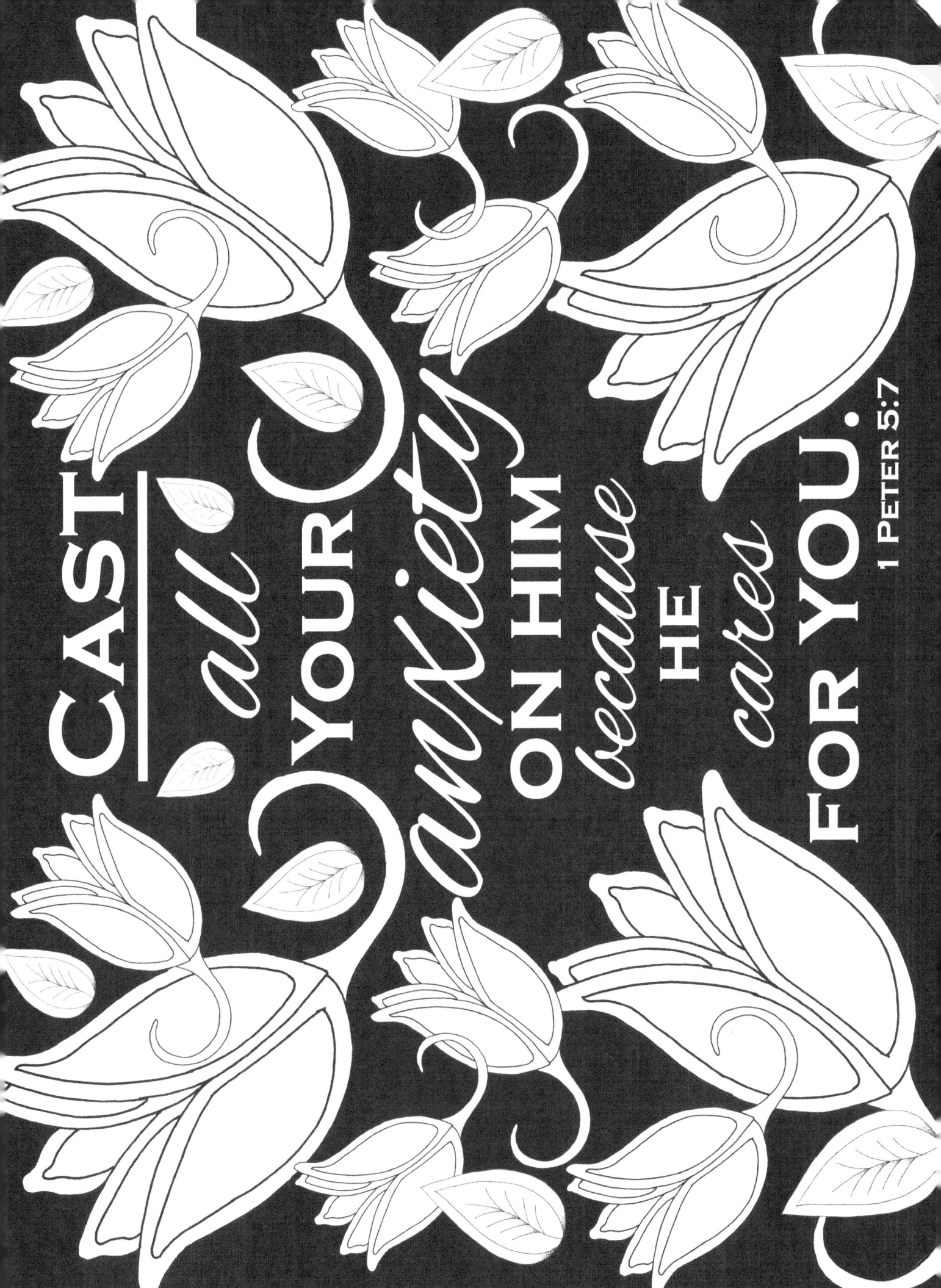

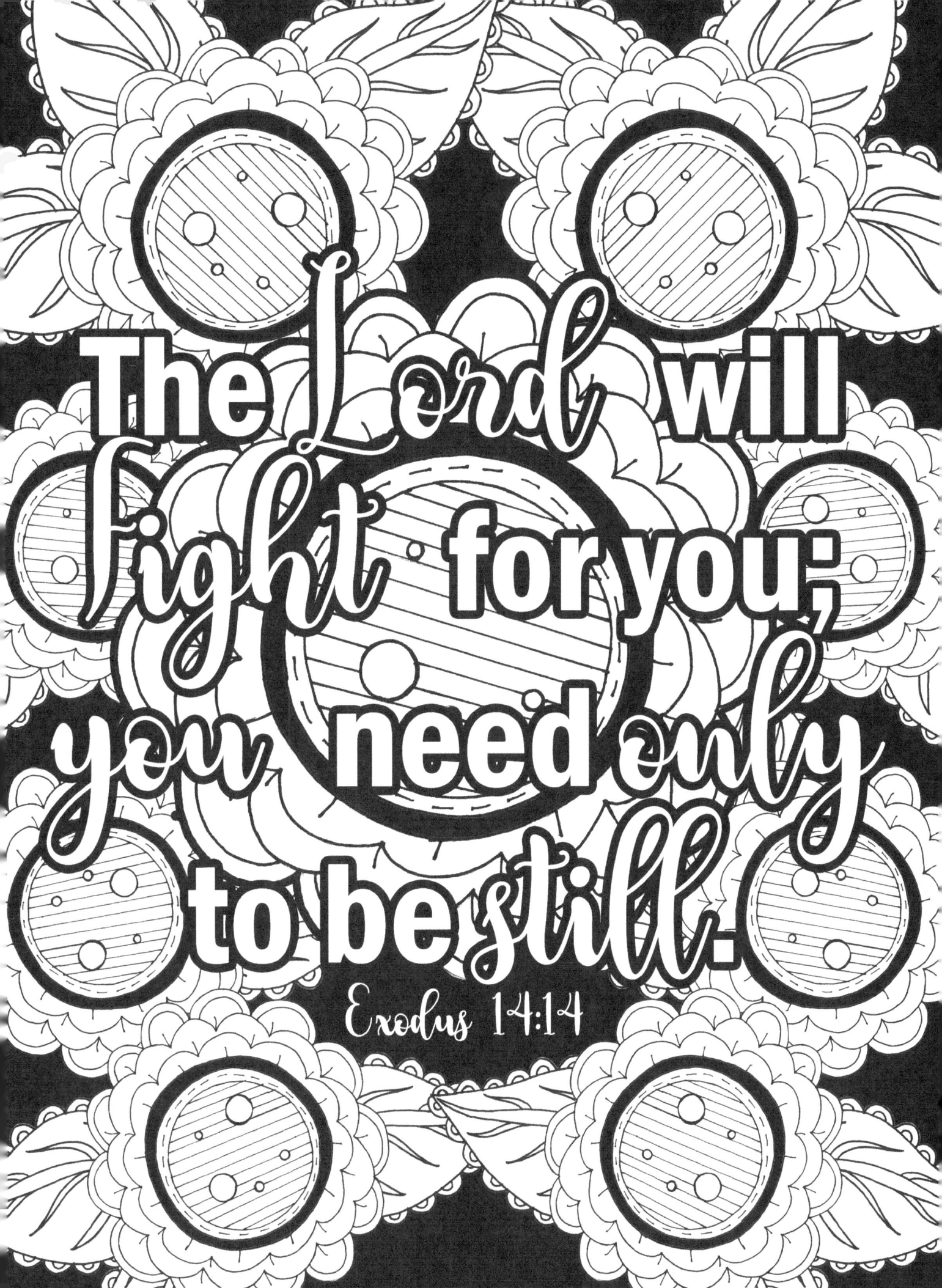

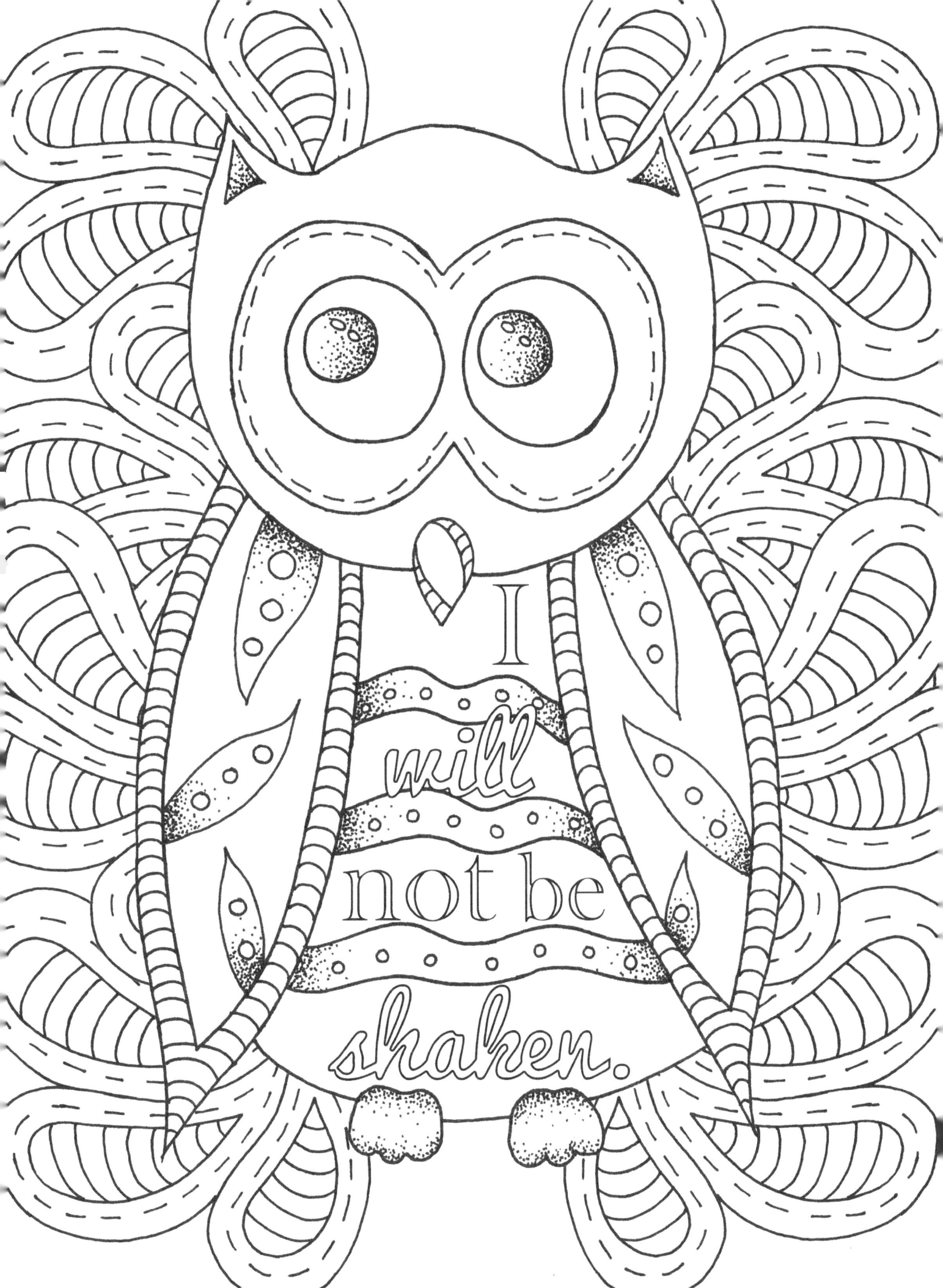

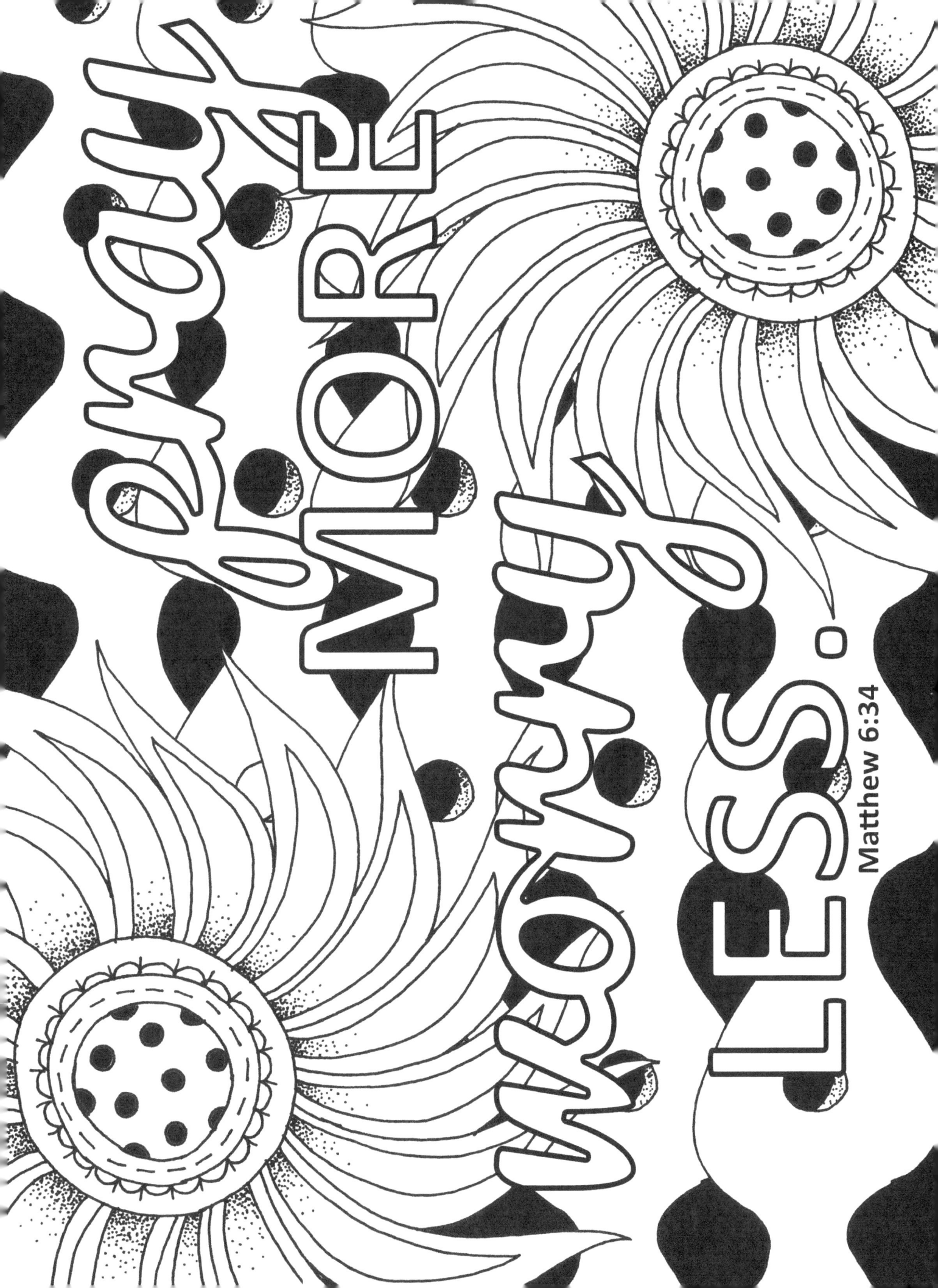

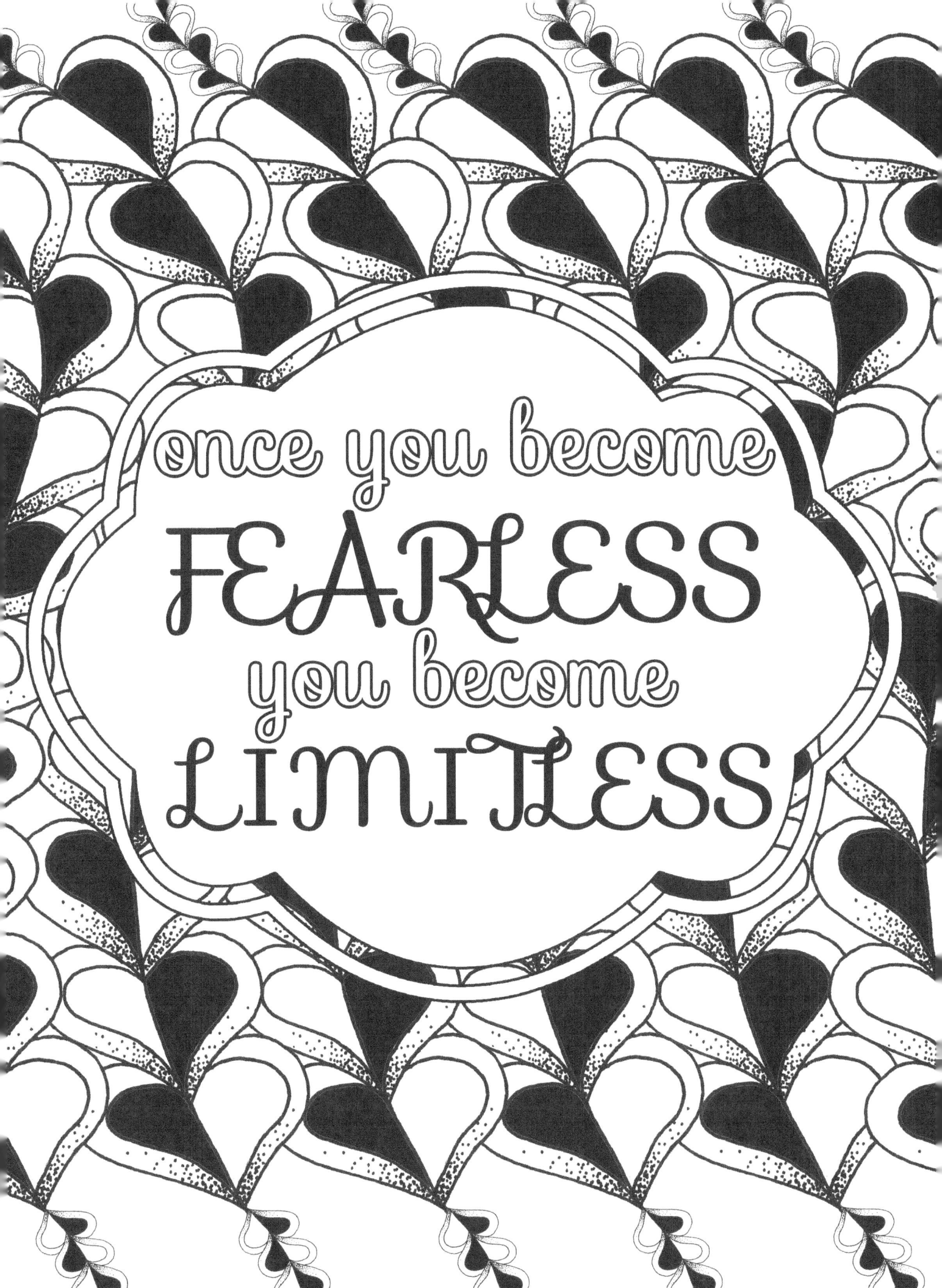

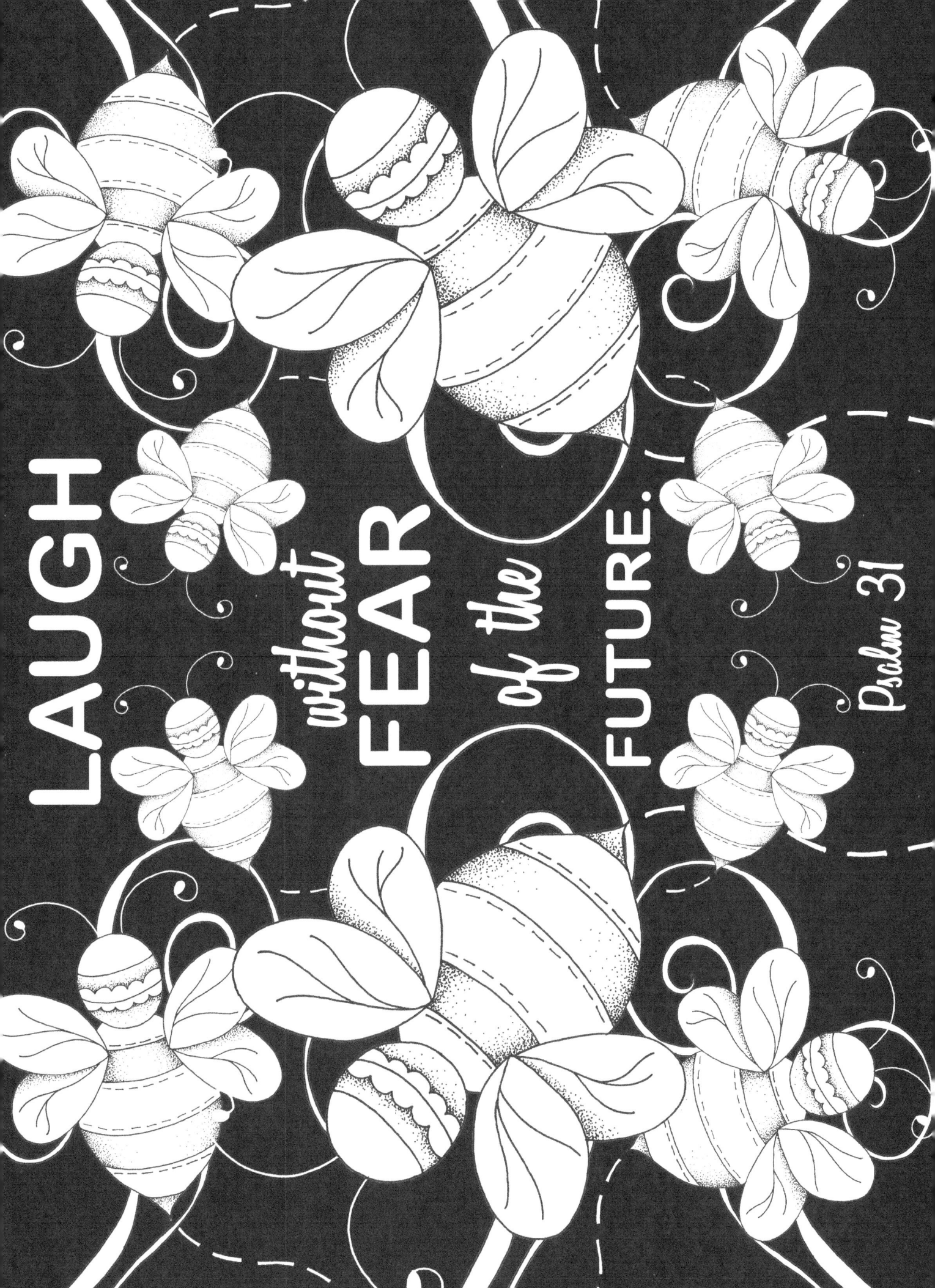

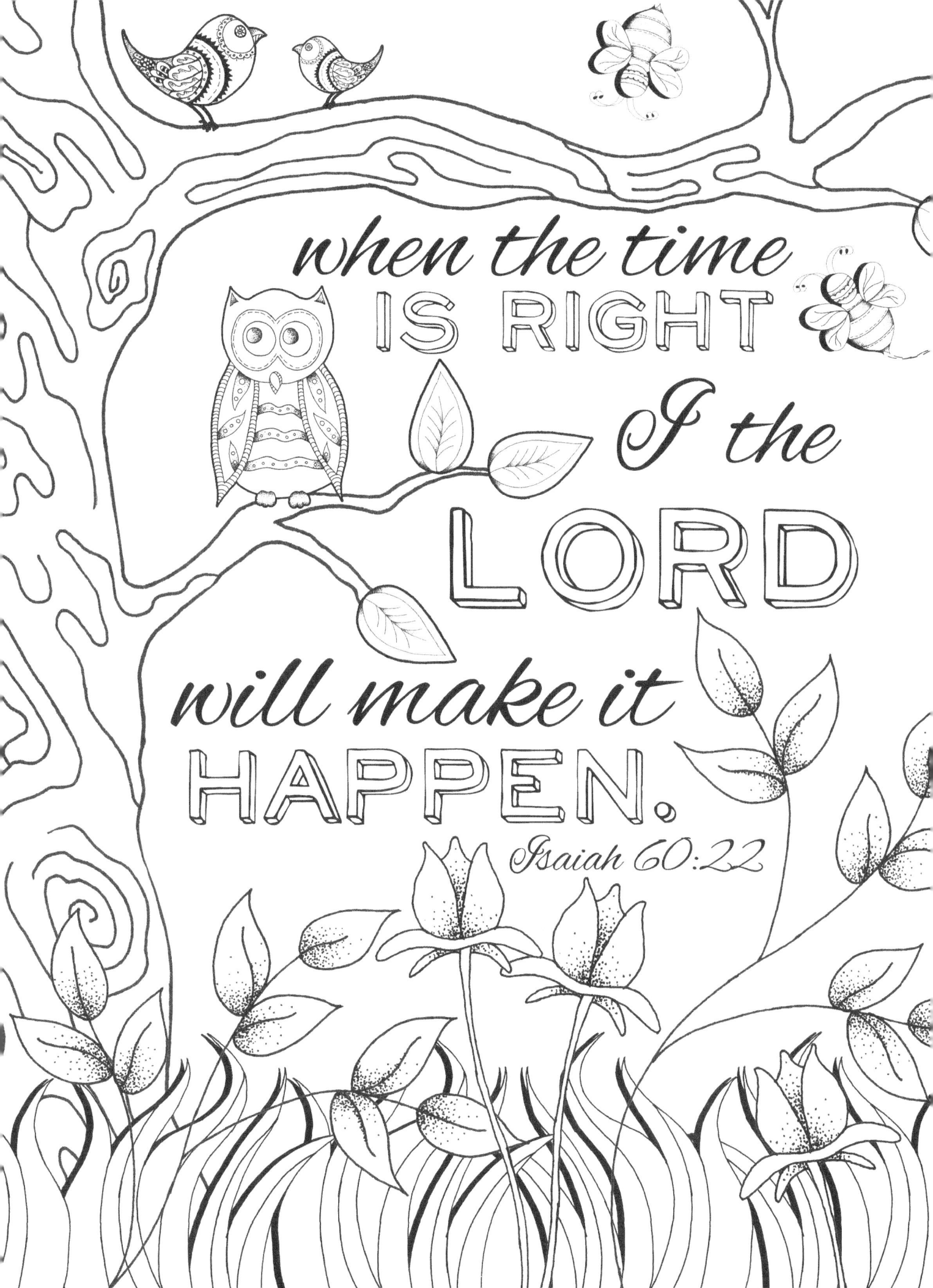

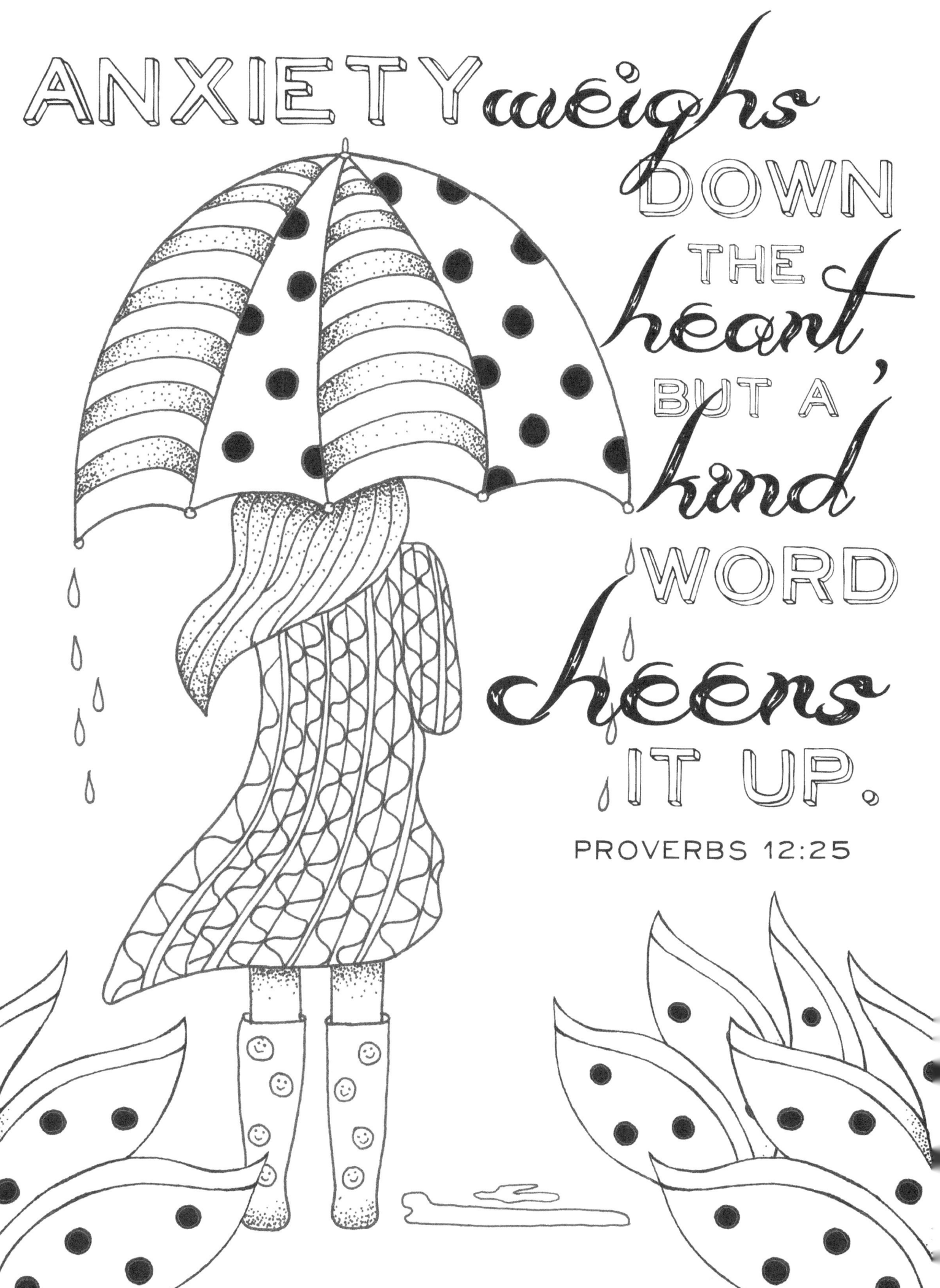

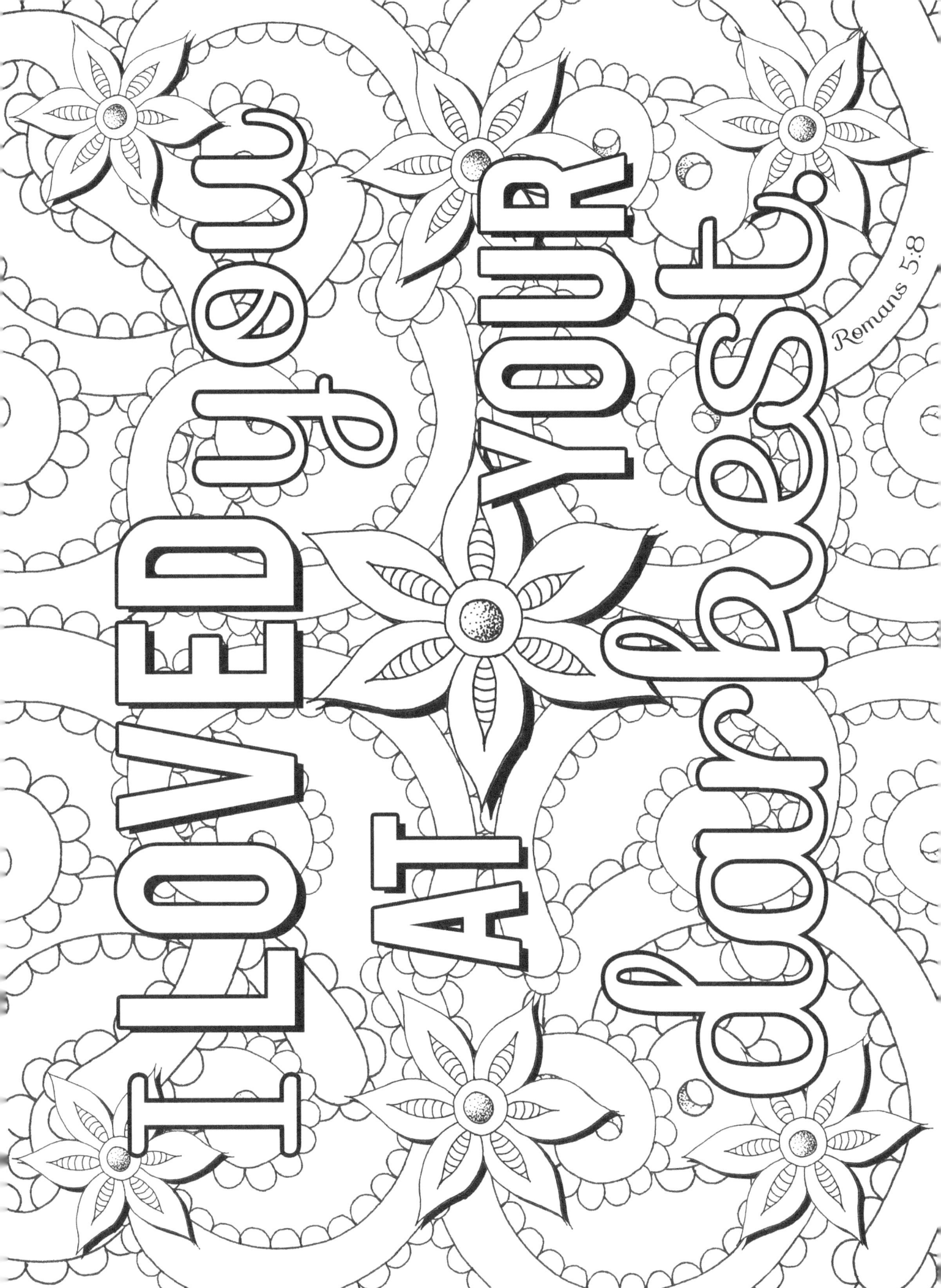

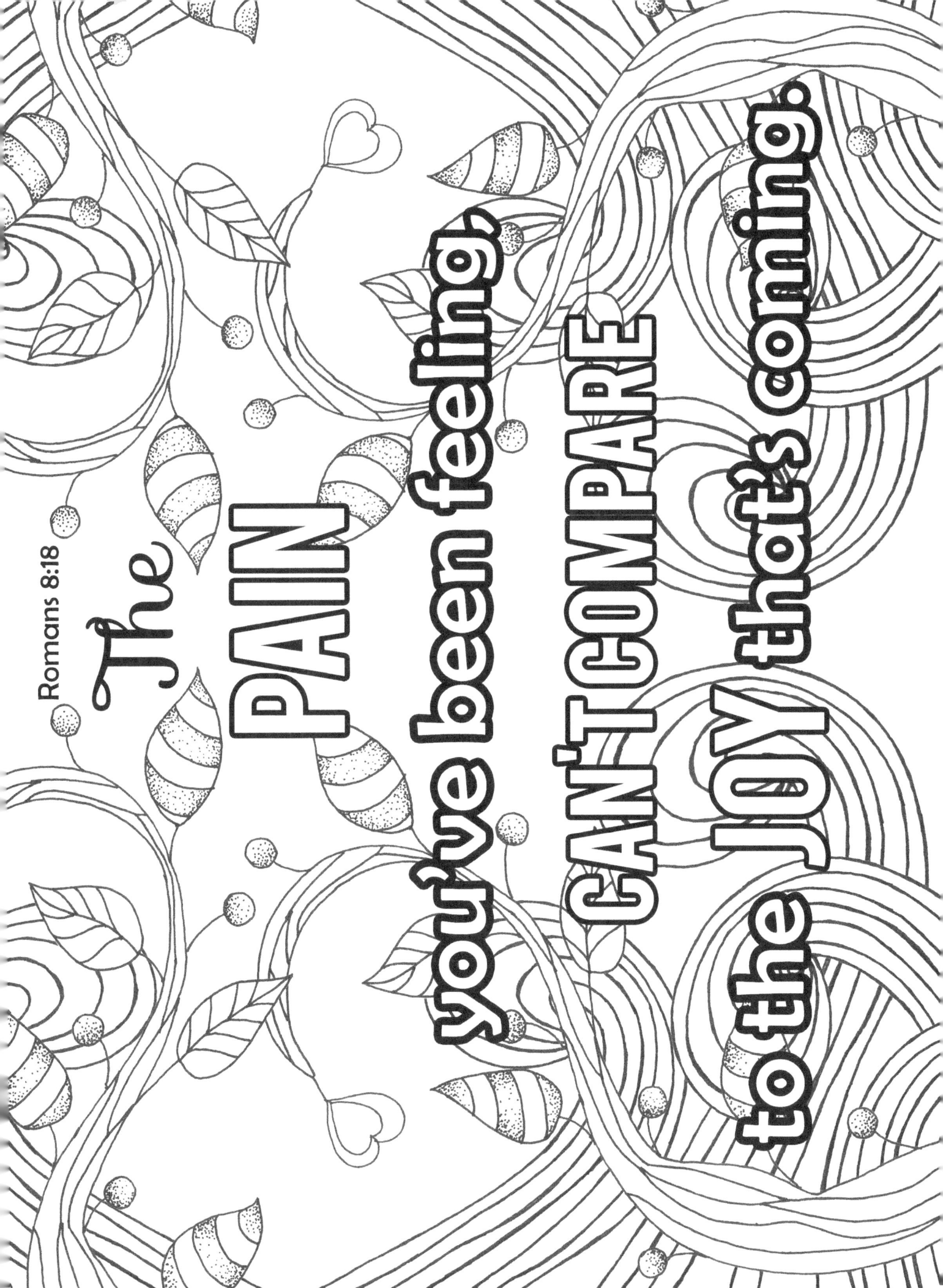

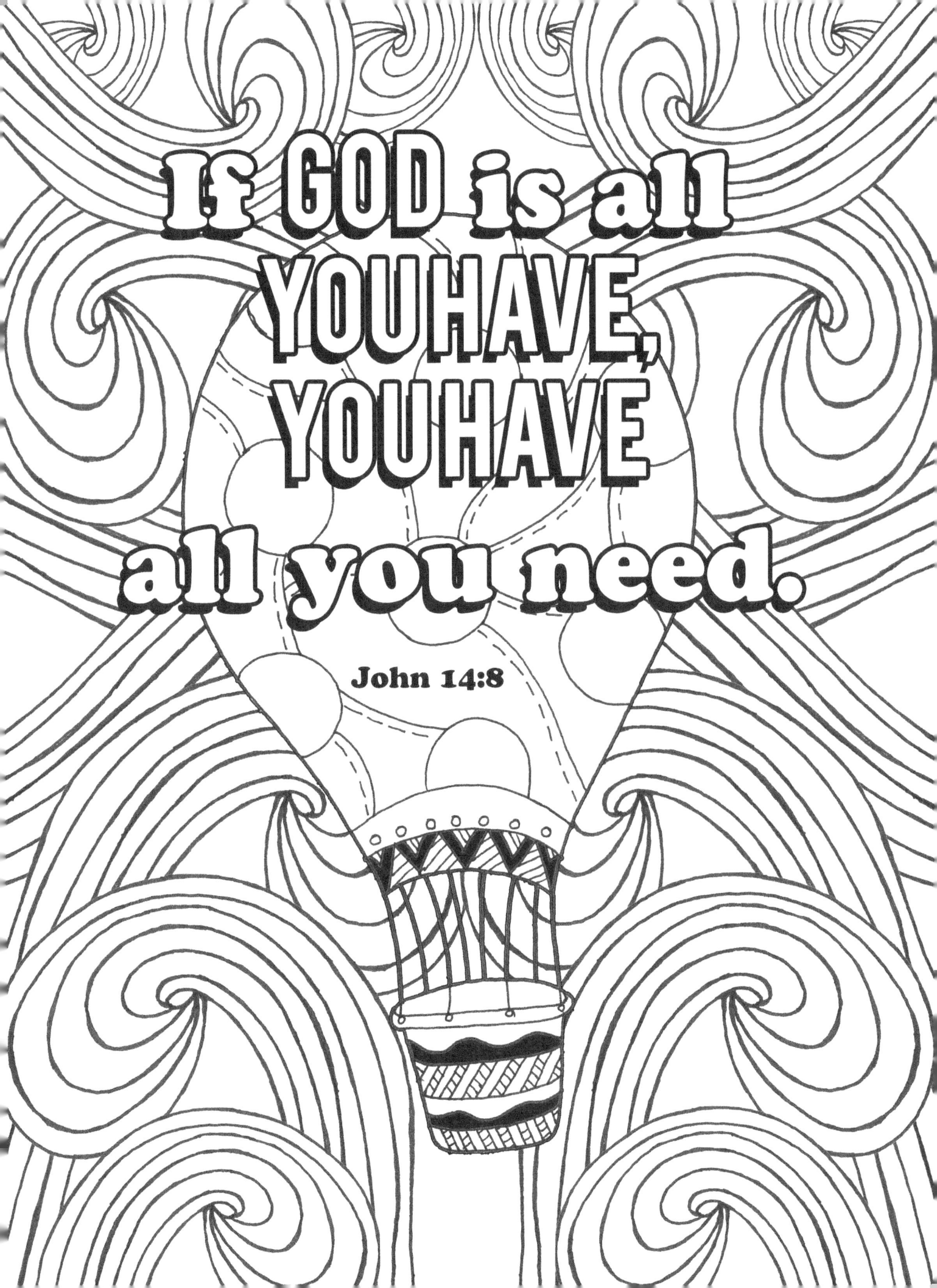

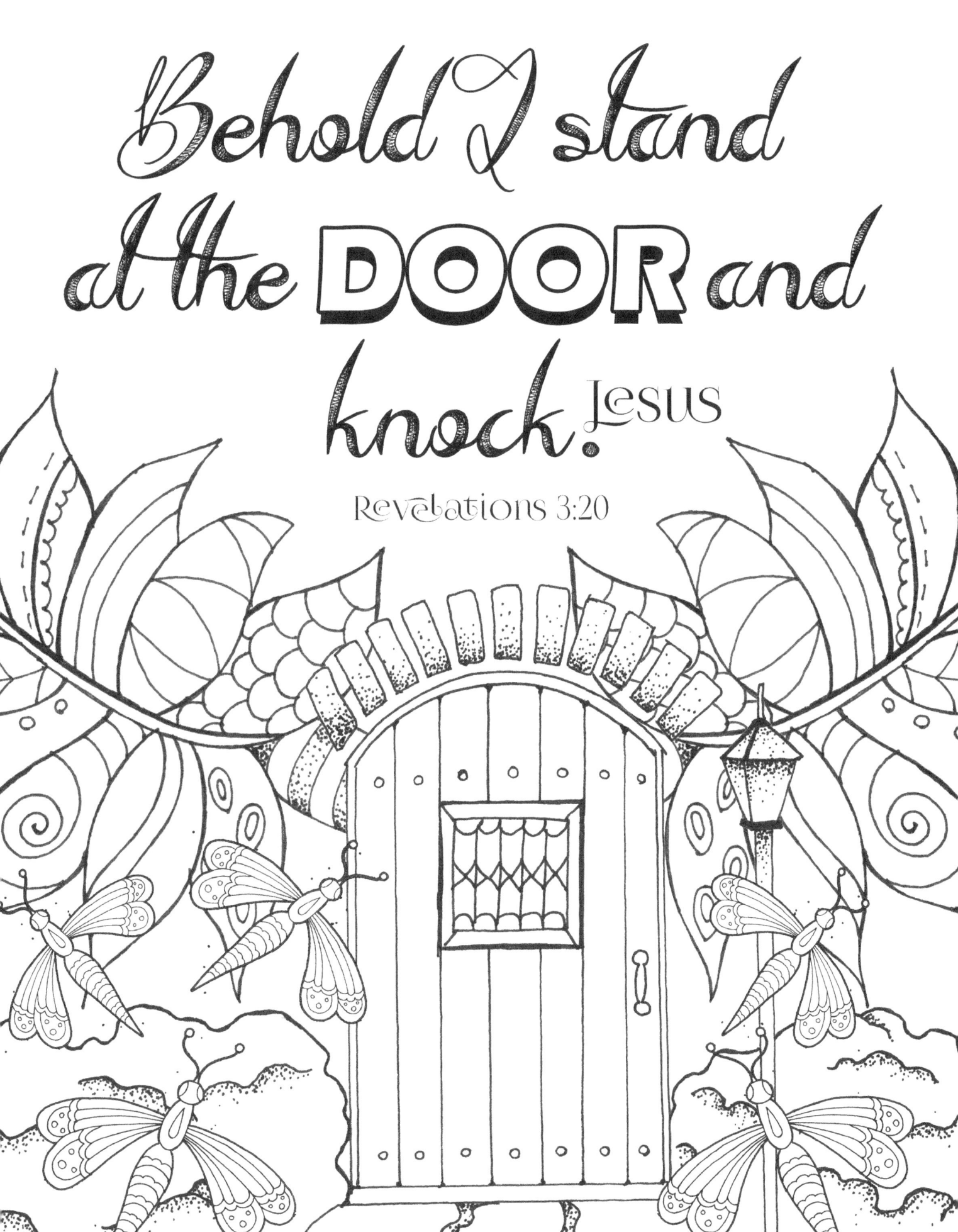

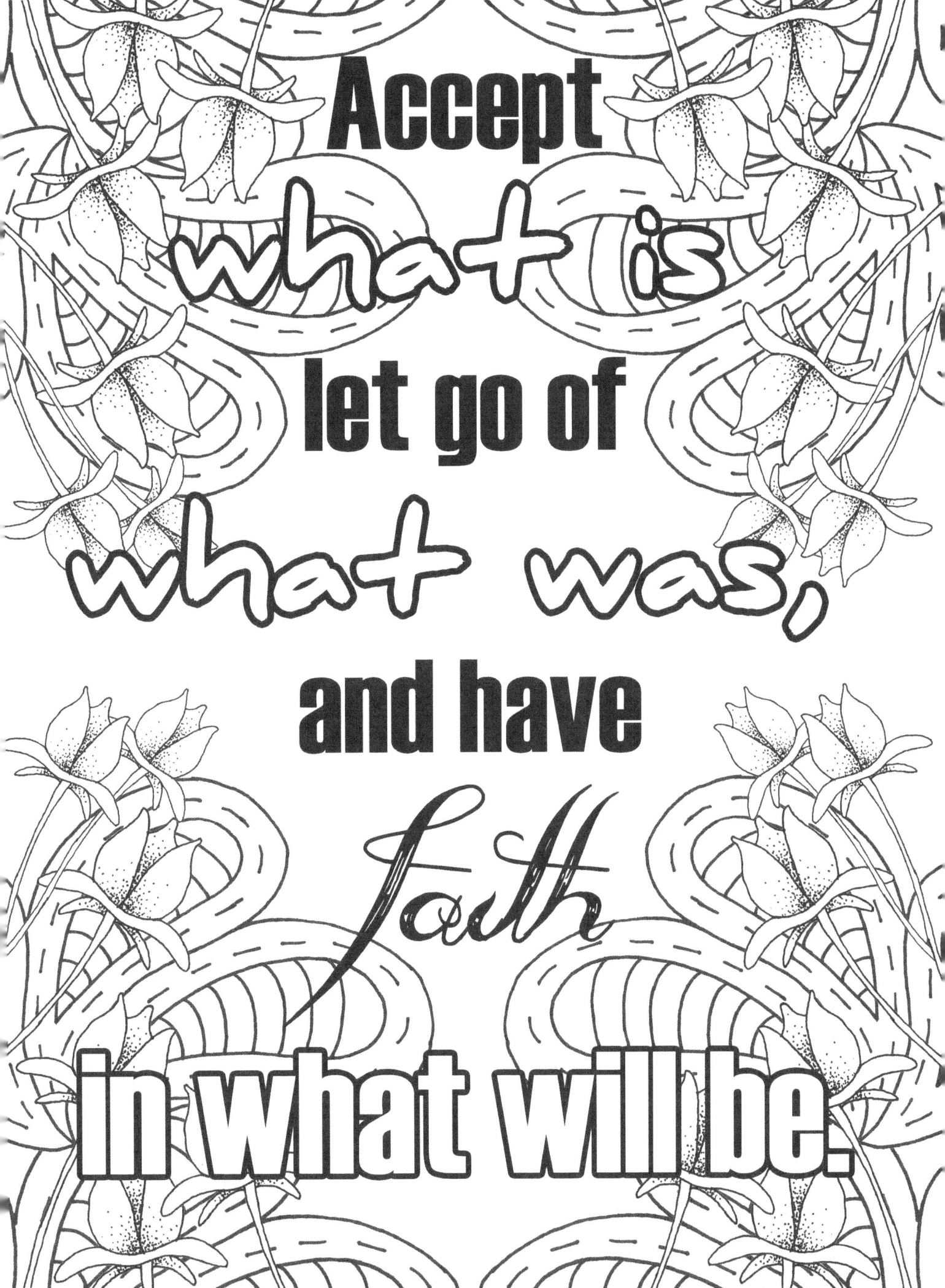

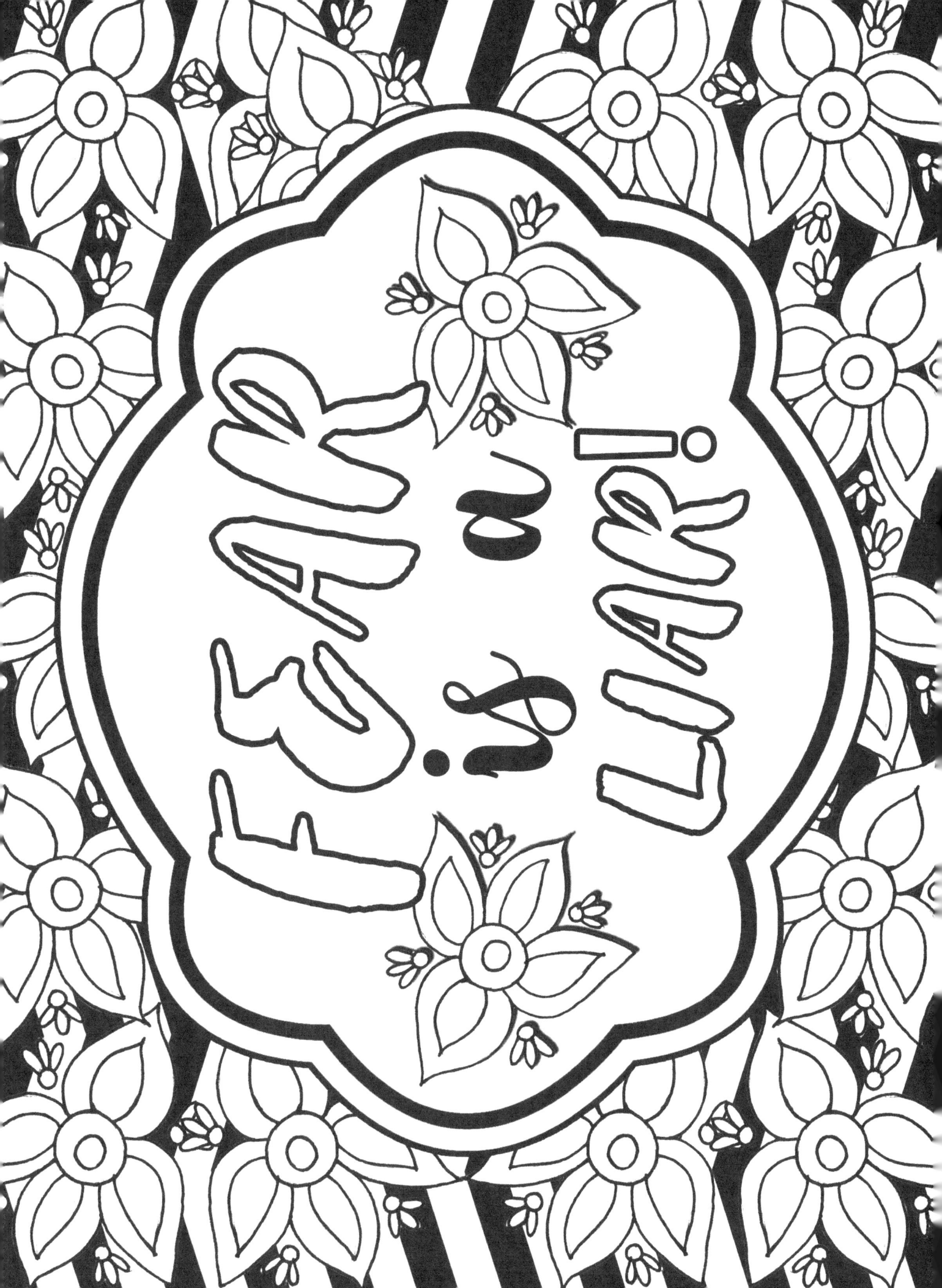

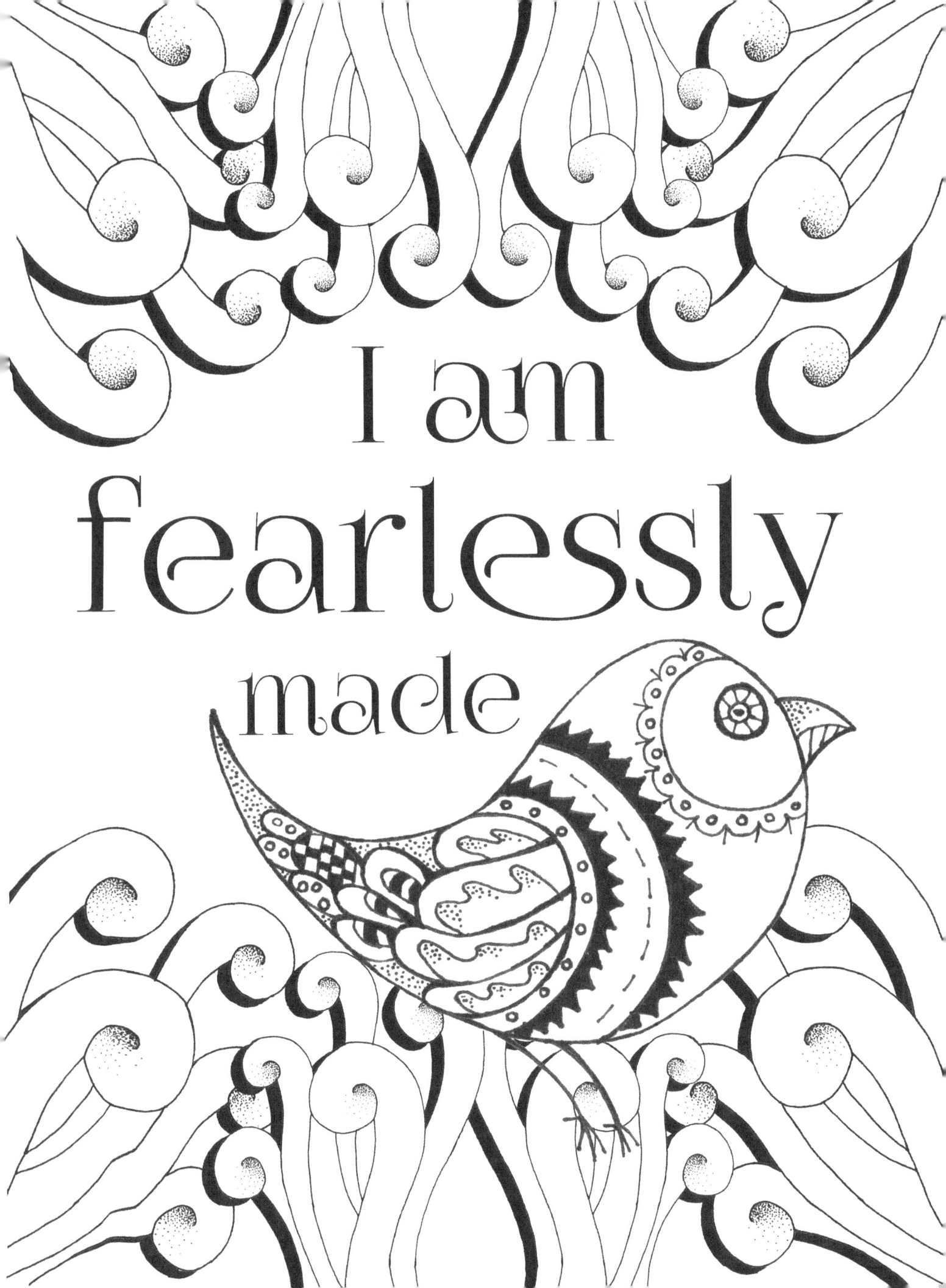

www.ingramcontent.com/pod-product-compliance
Lightning Source LLC
Chambersburg PA
CBHW080137240526
45468CB00009BA/2478